Night Rainbow

Ryan Stoute

Every 26 trillion years on the first day of the 26th month on Planet 26, the night rainbow appeared in the sky.

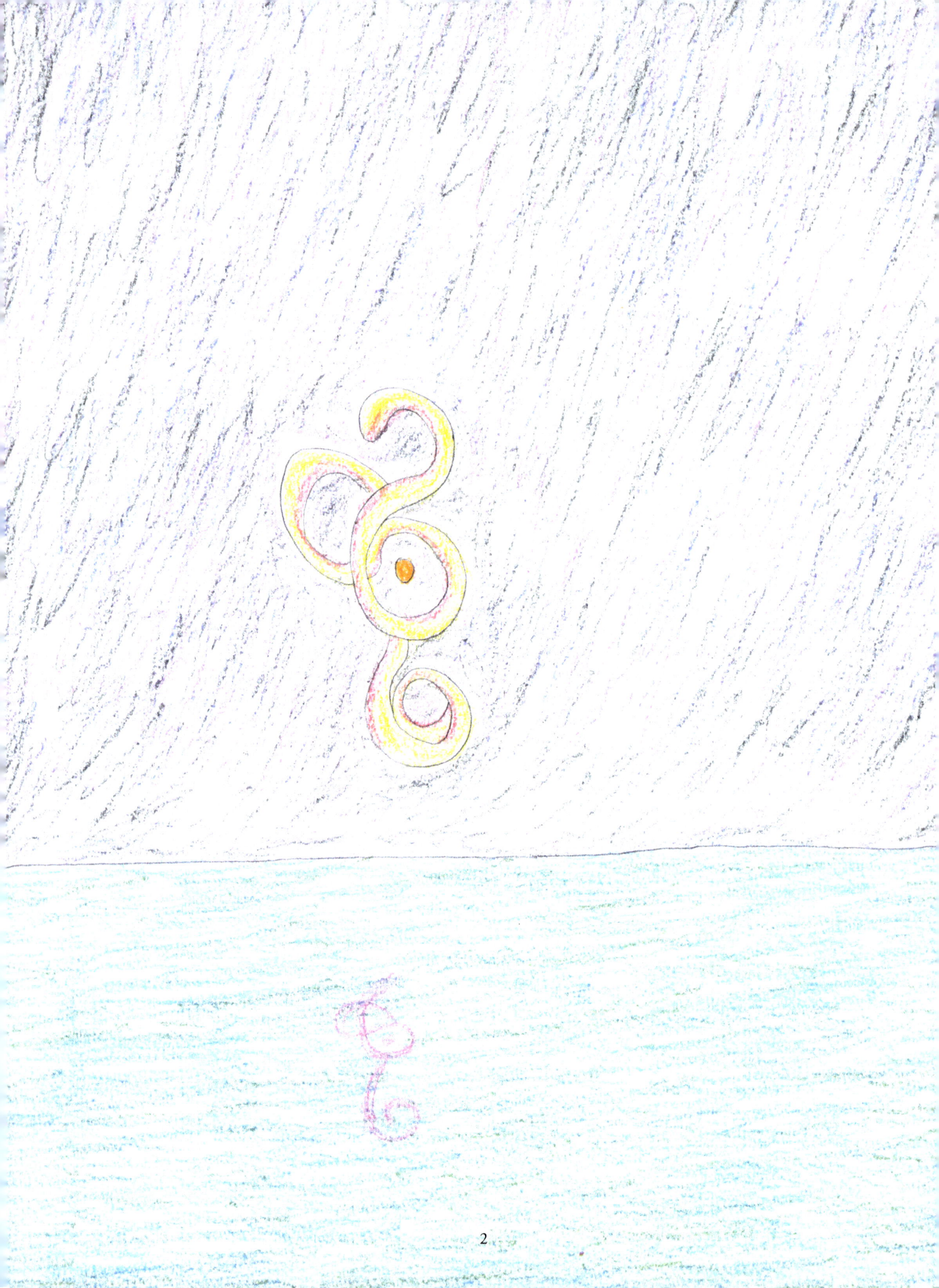

Bright, beautiful, and shimmering in the glowing darkness.

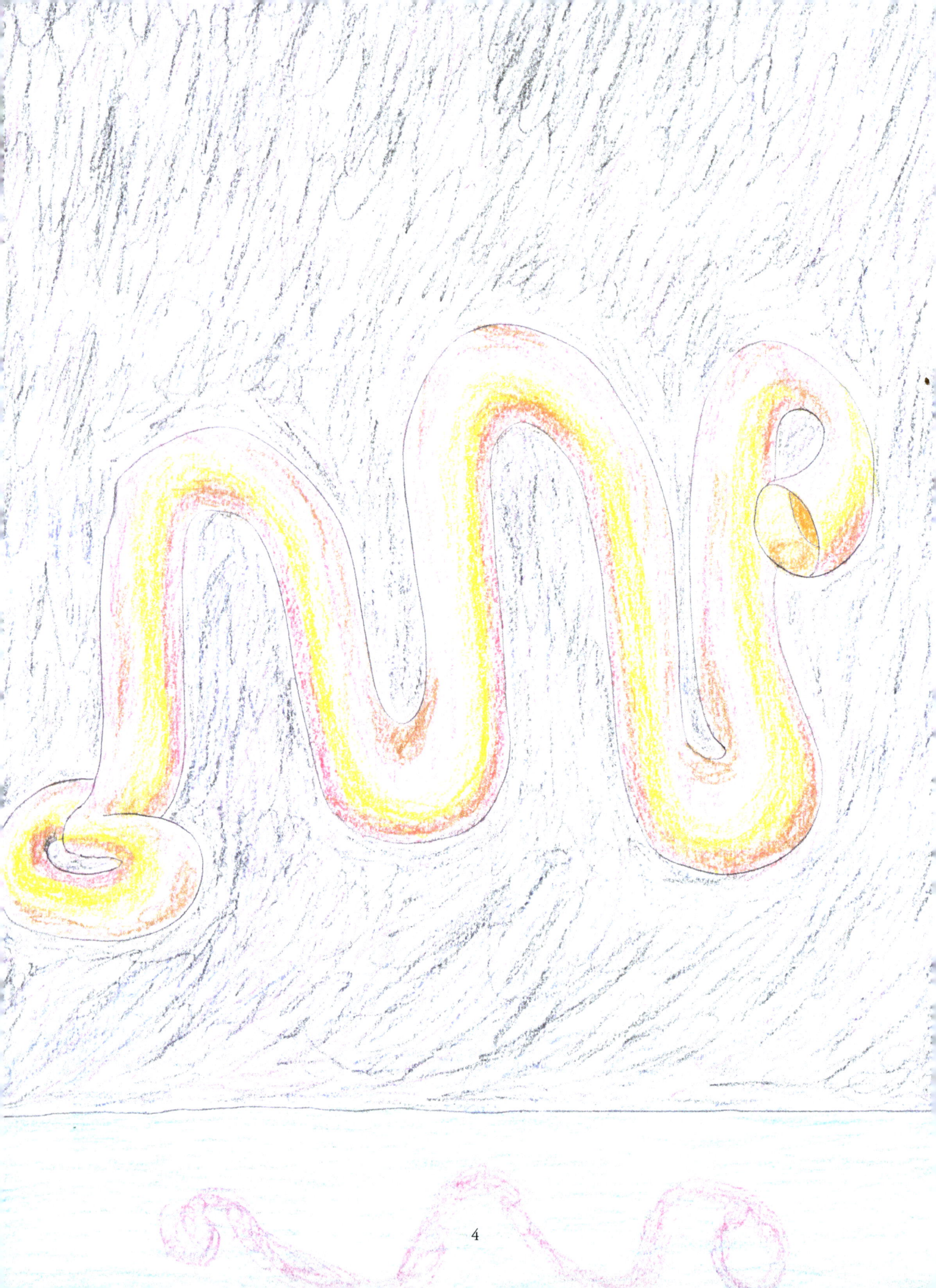

Thus it did until the 26th day of the 26th month. Then, on that day, the night rainbow hiccupped and swelled to astonishing proportions.

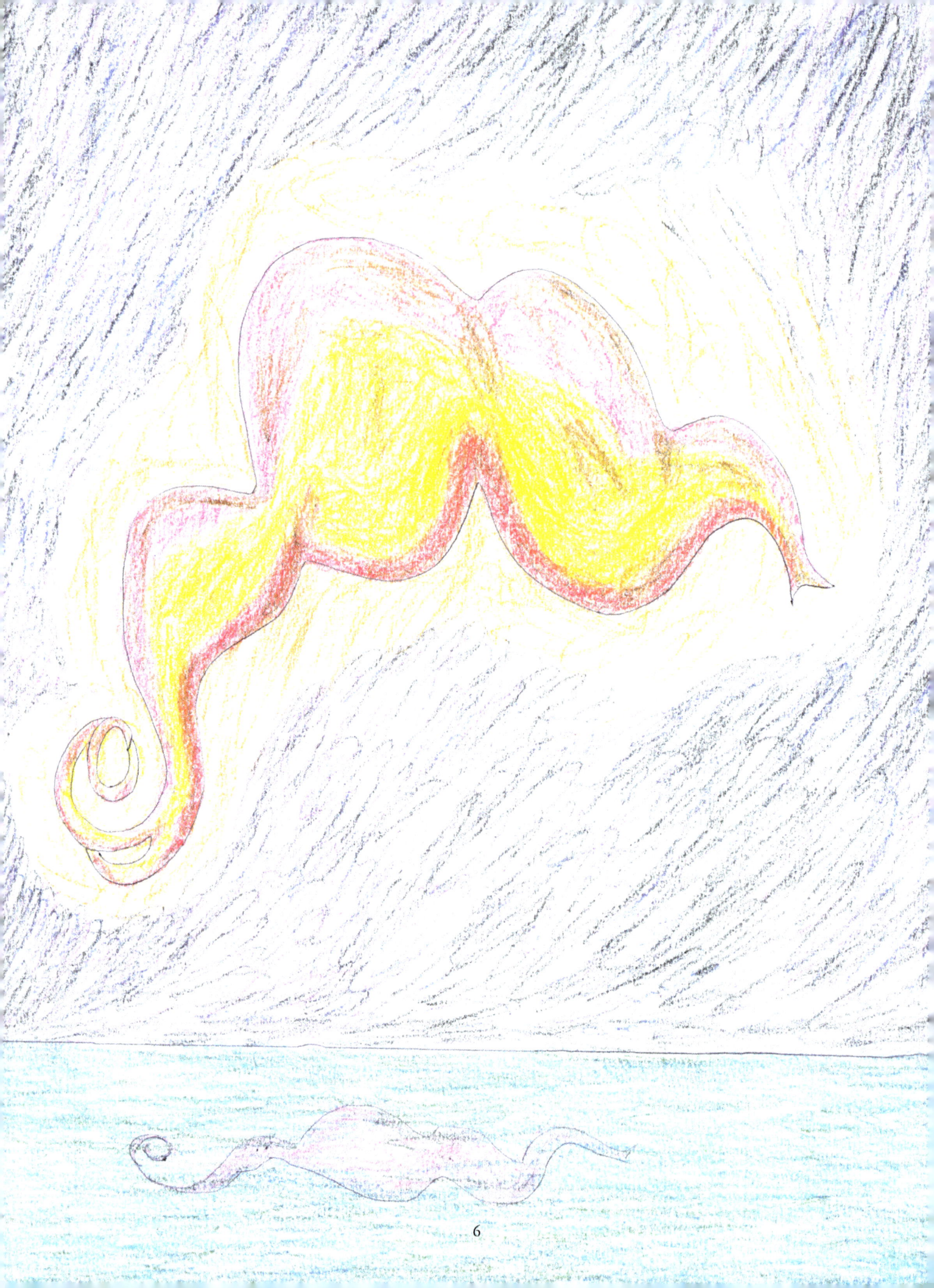

Growing and growing and growing...

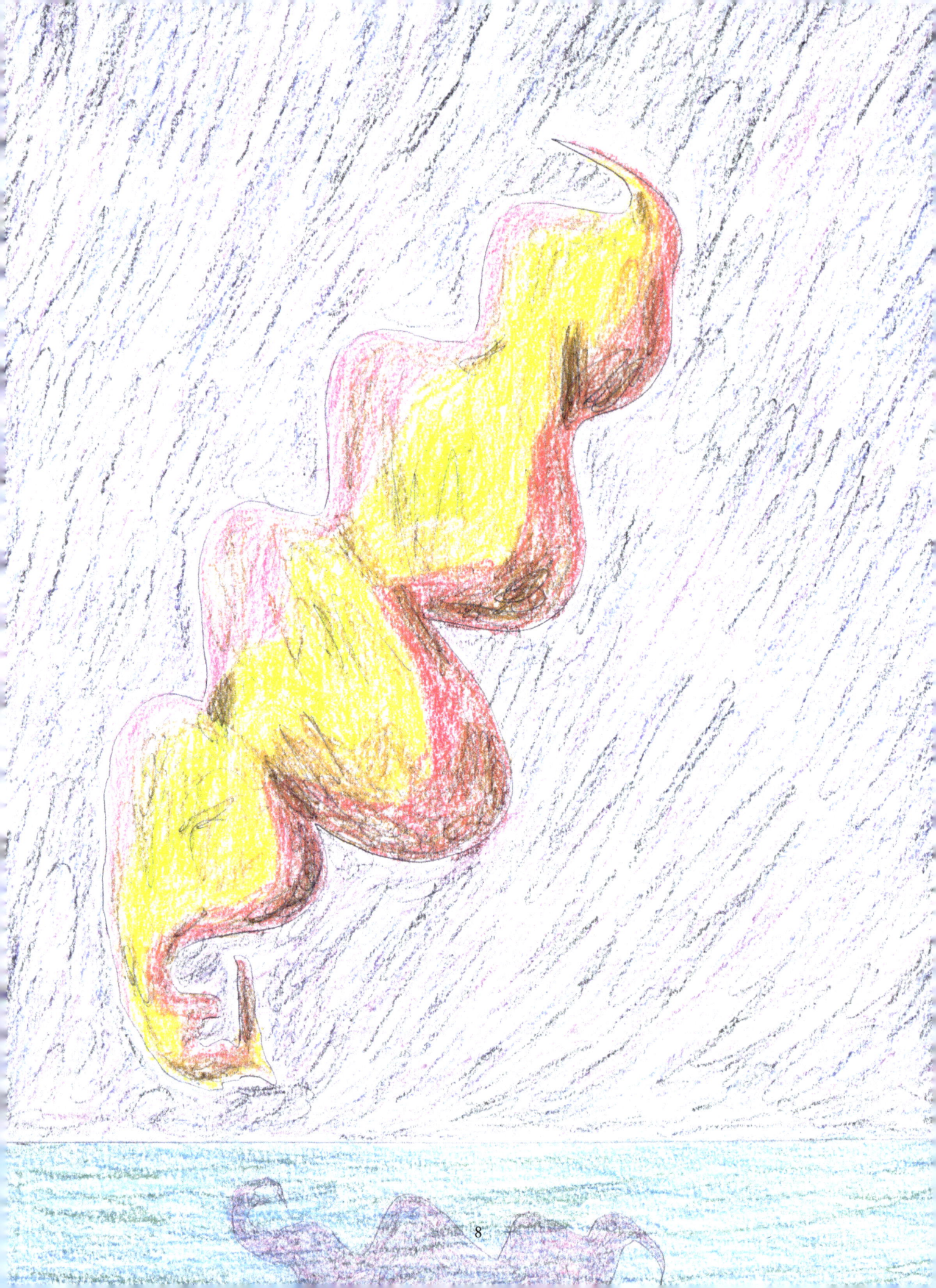

Until the behemoth outshone everything there is.

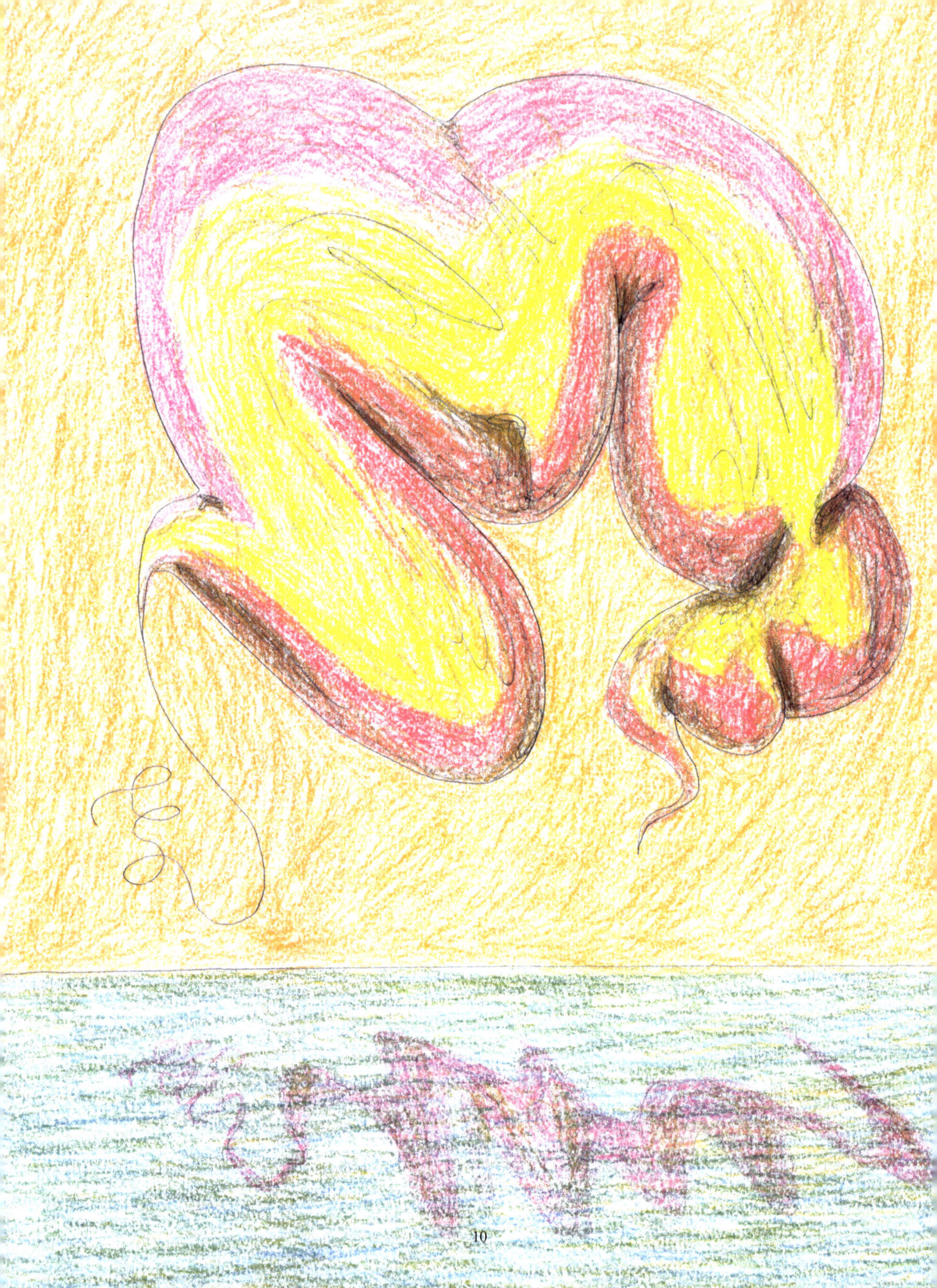

And once the rainbow reached maximum size...

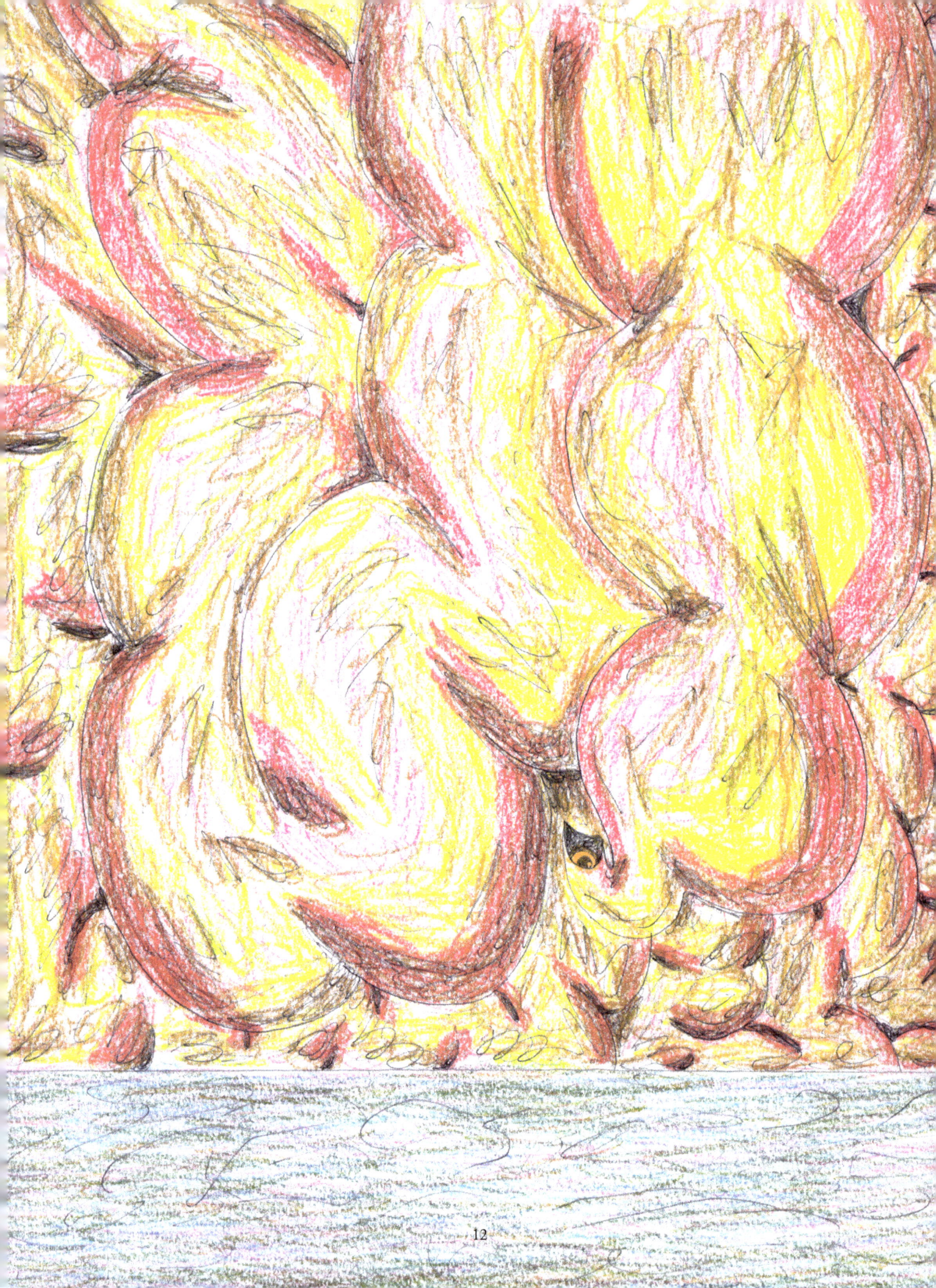

It rained an endless sea of ships.

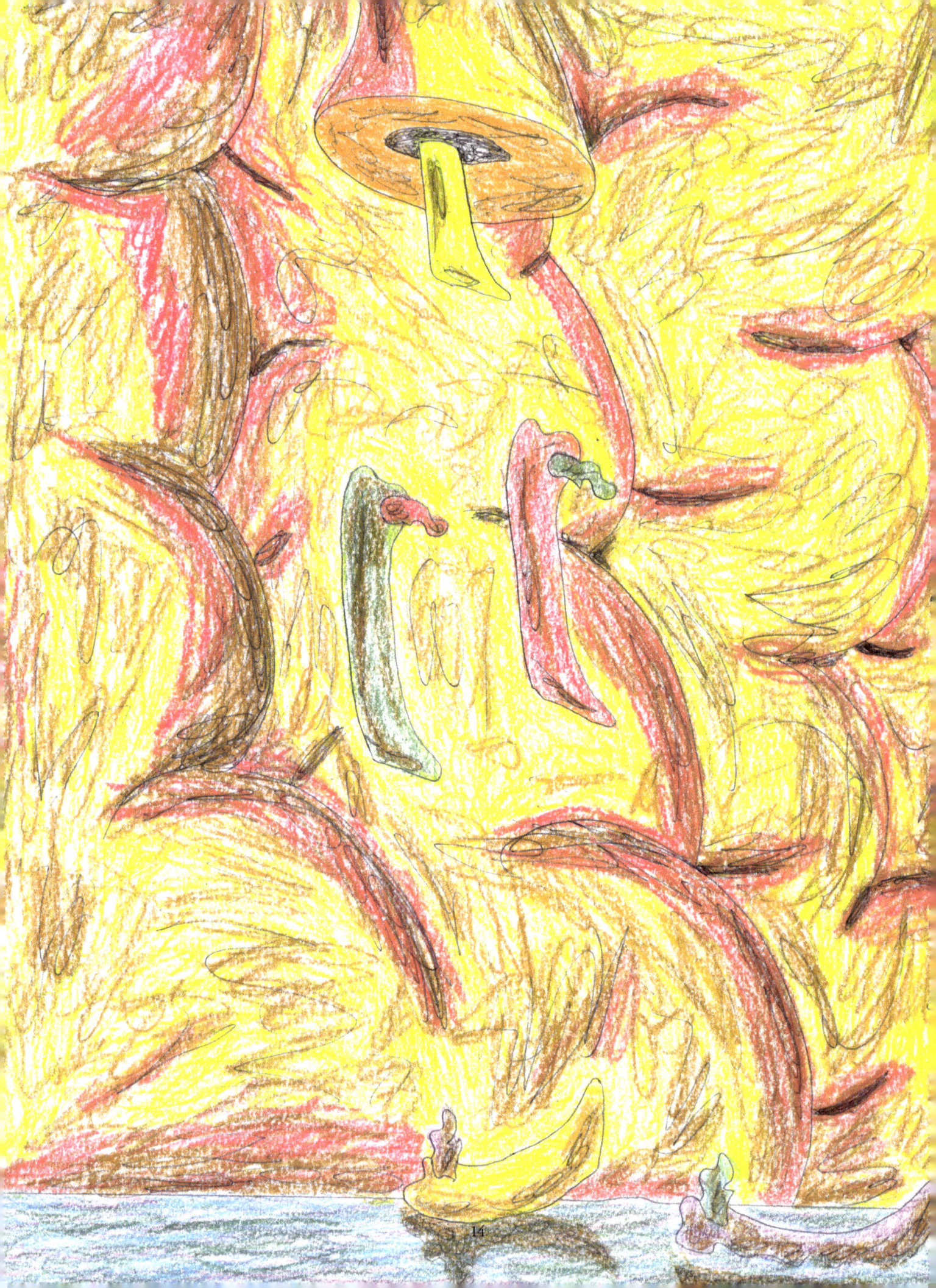

Huge in size and crammed with 260 trillion containers apiece.

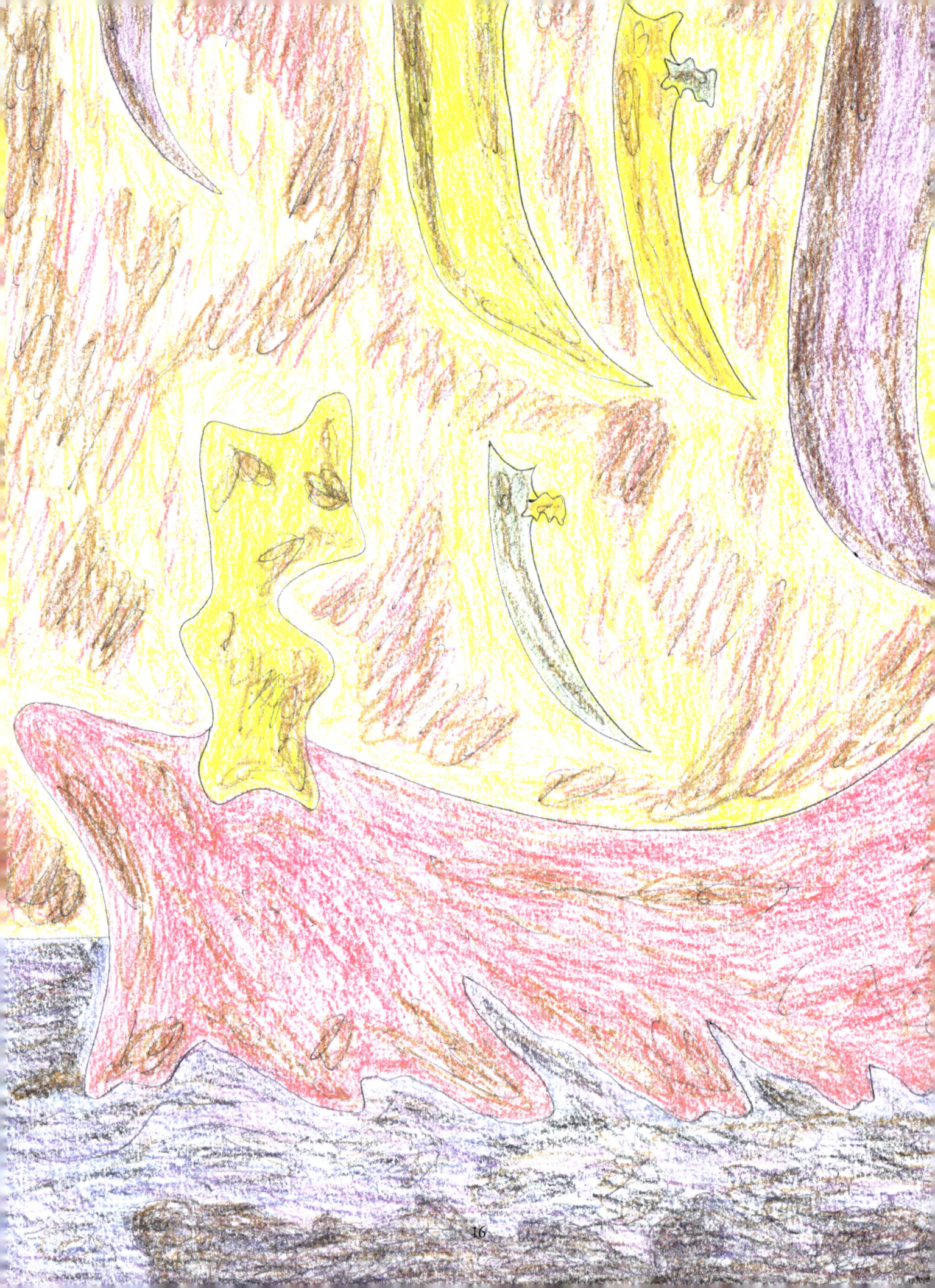

These powerful vessels swarmed the hypermassive orange hole and released their cargo.

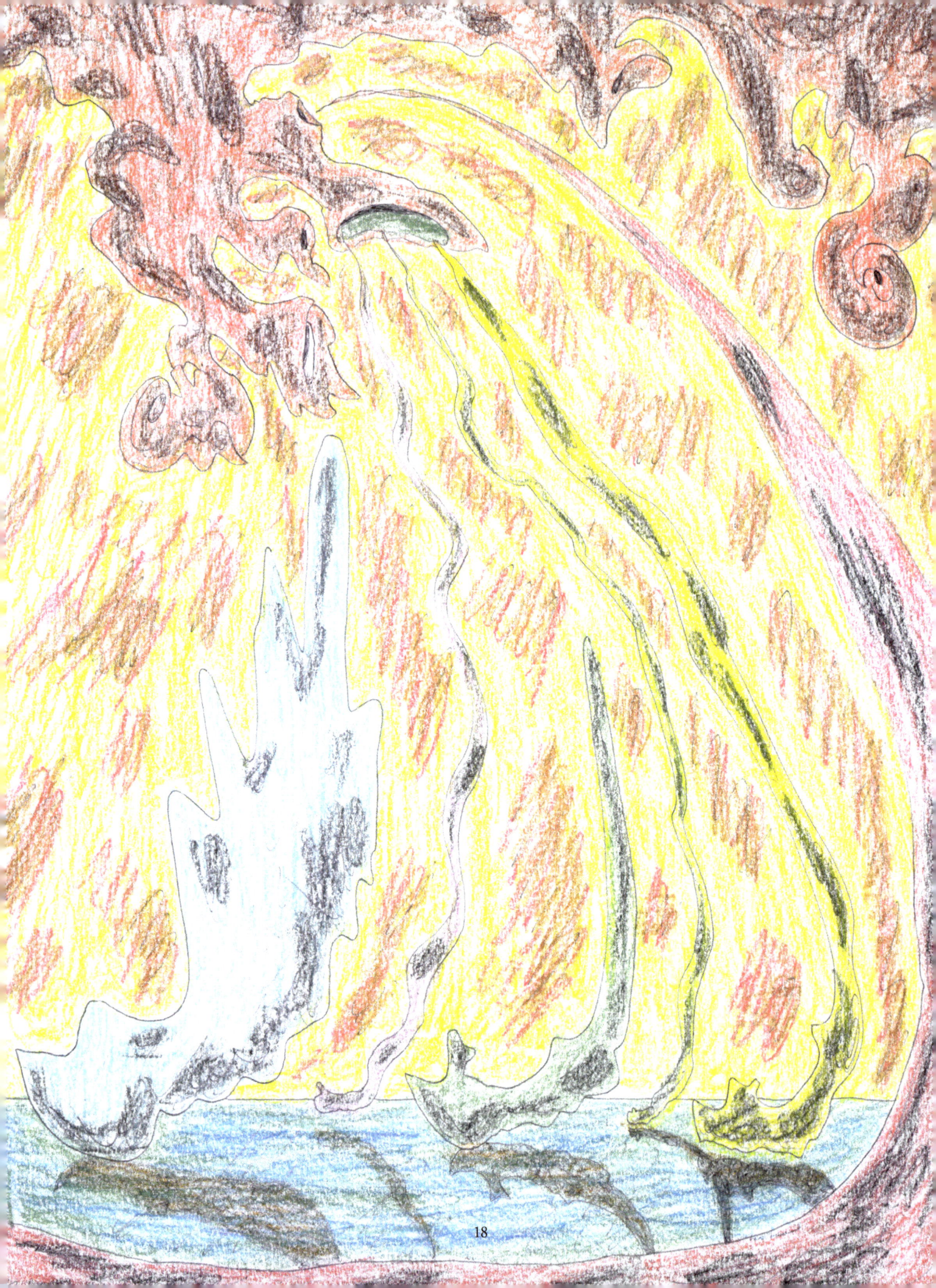

In turn, the mysterious portal shuttled the countless freight units off to receiver ships located in the 26^{th} trillionth dimension.

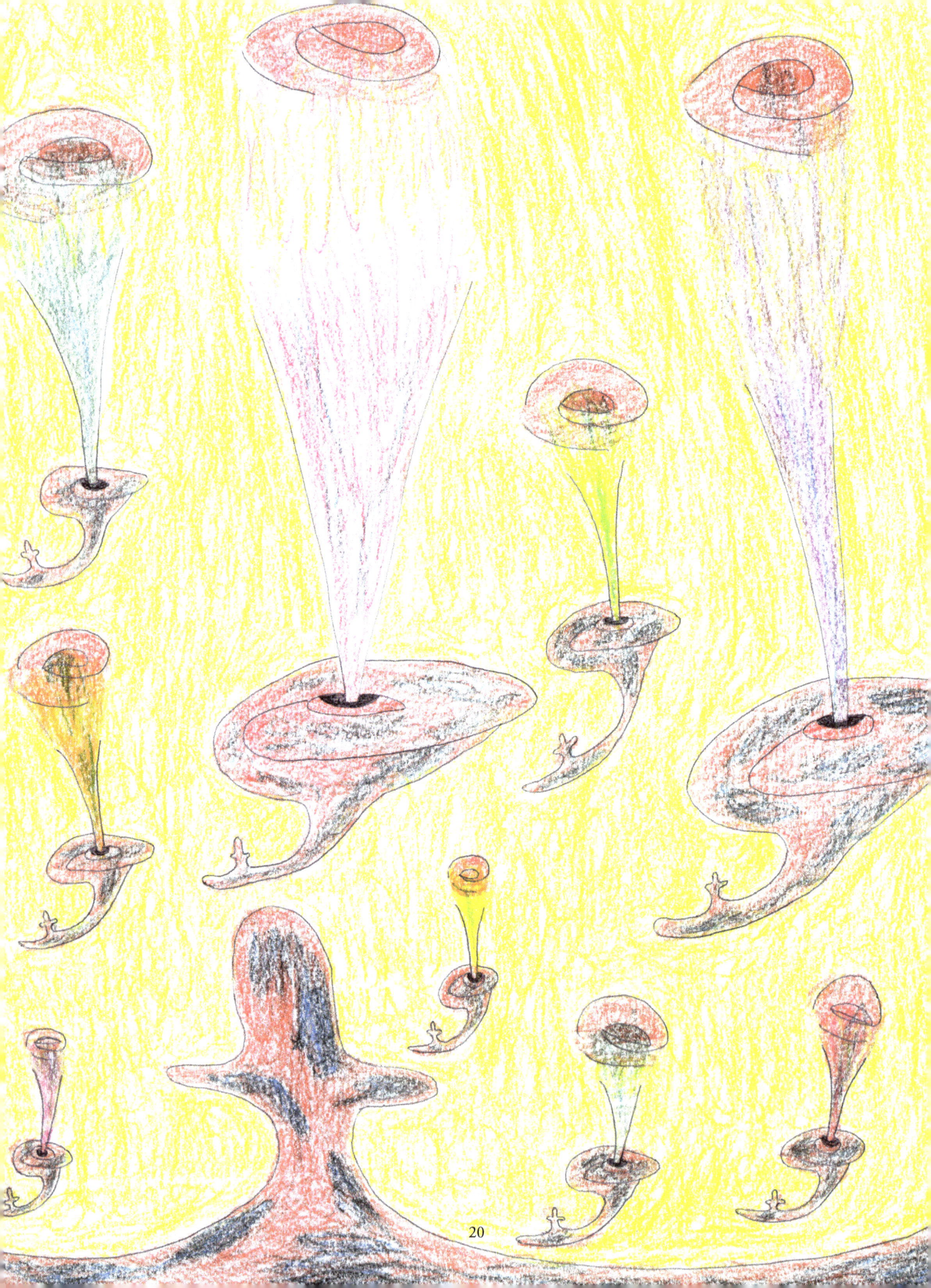

Five Fantastic Facts

1.) A year on Planet 26 consists of 26 months with 26 days apiece; and each day has 26 hours.

2.) Each freight container is 260 feet in length, 26 feet in width, and 26 feet in height.

3.) It would take a person around 8,244,546 years to count all 260 trillion containers aboard a ship at a rate of one per second (earth year of 365 days).

4.) If all 260 trillion freights from a ship were lined up in a single row, the length would total 67.6 quadrillion feet.

5.) 67.6 quadrillion feet is equivalent to more than 12.8 trillion miles or almost 2.18 light-years' distance.

Ryan Stoute currently lives in Chelsea, Massachusetts and is an author of twenty one Trafford Publishing books.

Order this book online at www.trafford.com
or email orders@trafford.com

Most Trafford titles are also available at major online book retailers.

© Copyright 2015 Ryan Stoute.

All rights reserved. No part of this publication may be reproduced, stored in a retrieval system, or transmitted, in any form or by any means, electronic, mechanical, photocopying, recording, or otherwise, without the written prior permission of the author.

Printed in the United States of America.

ISBN: 978-1-4907-5485-7 (sc)
978-1-4907-5476-5 (e)

Library of Congress Control Number: 2015901695

Because of the dynamic nature of the Internet, any web addresses or links contained in this book may have changed since publication and may no longer be valid. The views expressed in this work are solely those of the author and do not necessarily reflect the views of the publisher, and the publisher hereby disclaims any responsibility for them.

Our mission is to efficiently provide the world's finest, most comprehensive book publishing service, enabling every author to experience success. To find out how to publish your book, your way, and have it available worldwide, visit us online at www.trafford.com

Any people depicted in stock imagery provided by Thinkstock are models, and such images are being used for illustrative purposes only.
Certain stock imagery © Thinkstock.

Trafford rev. 02/04/2015

 www.trafford.com

North America & international
toll-free: 1 888 232 4444 (USA & Canada)
fax: 812 355 4082

Planet 26

www.ingramcontent.com/pod-product-compliance
Lightning Source LLC
Chambersburg PA
CBHW052143170526
45159CB00017B/3144